KU-799-559

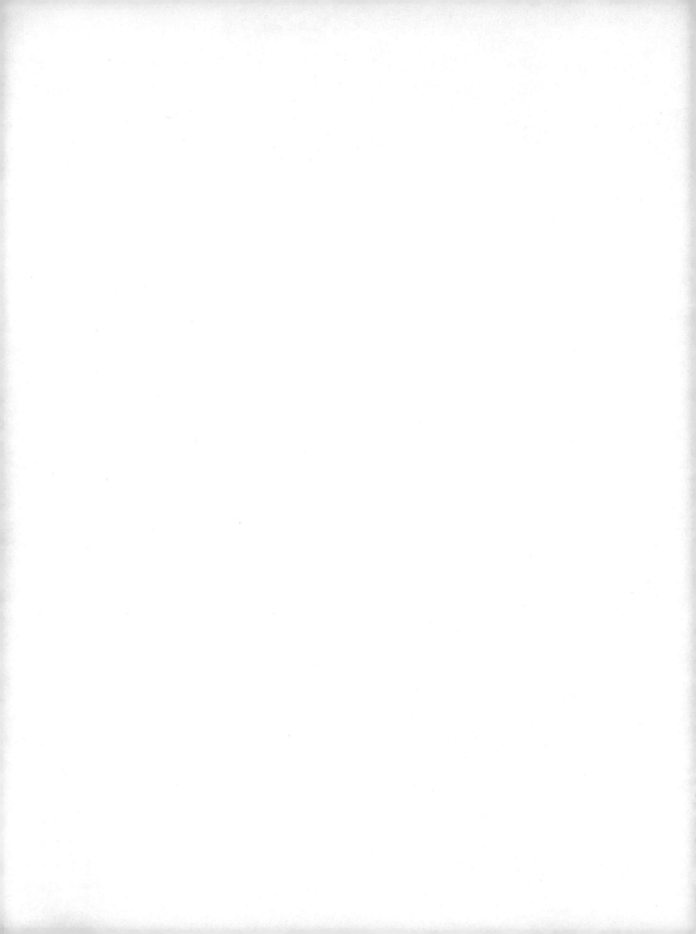

BERYL
COOK

One Man Show

BERYL COOK

One Man Show

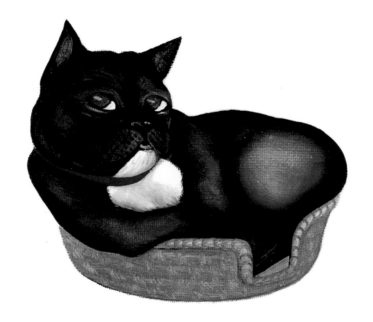

John Murray
Gallery Five

© Beryl Cook 1981

First published 1981
by John Murray (Publishers) Ltd
50 Albemarle Street, London W1X 4BD
and Gallery Five Ltd, 14 Ogle Street, London W1P 7 LG

All rights reserved
Unauthorised duplication
contravenes applicable laws

Printed in Great Britain by
The Fakenham Press

British Library Cataloguing in Publication Data
Cook, Beryl
 One man show.
 1. Cook, Beryl
 2. Art, English
 I. Title
 759.2 ND497.C/

ISBN 0-7195-3881-5

Foreword

Having been asked to write an introduction to Beryl Cook's new book, I accepted the offer with the speed and enthusiasm with which I would have said Yes to a dinner at Les Pyramides; or a walkover at the next Parliamentary Election.

I admire Mrs Cook's paintings greatly. I was bowled over when I first saw a reproduction. I voted her *Seven Years And a Day* as the Kids' Book of 1980. I asked her to tea and liked her as much as did the staff at the House of Commons tea-room— which is a sure sign of being what the Americans call 'a very lovely person'—though frankly this book would be a joy had it been composed by a misogynist gorgon.

She manages with the use of paint and brush to conjure up the passion, humour, self-delusion and embarrassment that make the world go by, but she manages to stop it and paint it as it is. It is fashionable, I know, to compare artists with their contemporaries. In Beryl Cook's case, this is unwarranted.

Where Lowry missed it, Bacon distorted it, Dali made it sculptural, Sutherland pessimistic, Peter Scott ornithological, Hockney antiseptic . . . Beryl Cook serves up pure unadulterated pleasure. You look at a painting and get the sort of feeling associated with receiving a telegram that says: Start celebrating good news follows. You read the blurb and look again and smile the smile of spiritual contentment.

Anthropologists will look back to the latter quarter of this century and try to read into her art some deep significance or social comment. To hell with that. Here is a book to have and cherish; to give to friends and take pride and pleasure in their enjoyment.

You who have bought this book do not need further encouragement, but if you are lucky enough to get her to come to tea it will be helpful for you to know that she takes milk and two saccharin tablets, refuses egg sandwiches and has a husband called John, who was the boy next door and now sells secondhand cars: I would buy any that he recommends.

Clement Freud

Chinese Restaurant

We always enjoy visiting Liverpool, not just for the splendid art galleries, but also for the public houses and Chinese restaurants where we spend a good deal of our time.

I well remembered the ducks hanging in a line, the chopper flashing down and the oil-cloth on the tables, but strained my brain considerably in bringing back and assembling all the other details. MY hand is the one at the front, manipulating the chopsticks with great skill to pick up one grain of rice at a time; unfortunately this is not quite fast enough: the food is so delicious that in reality I use a spoon and fork.

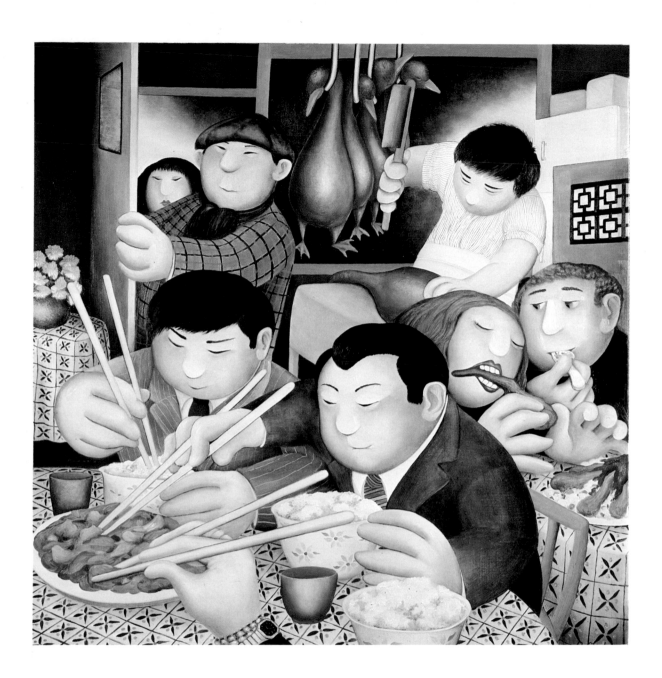

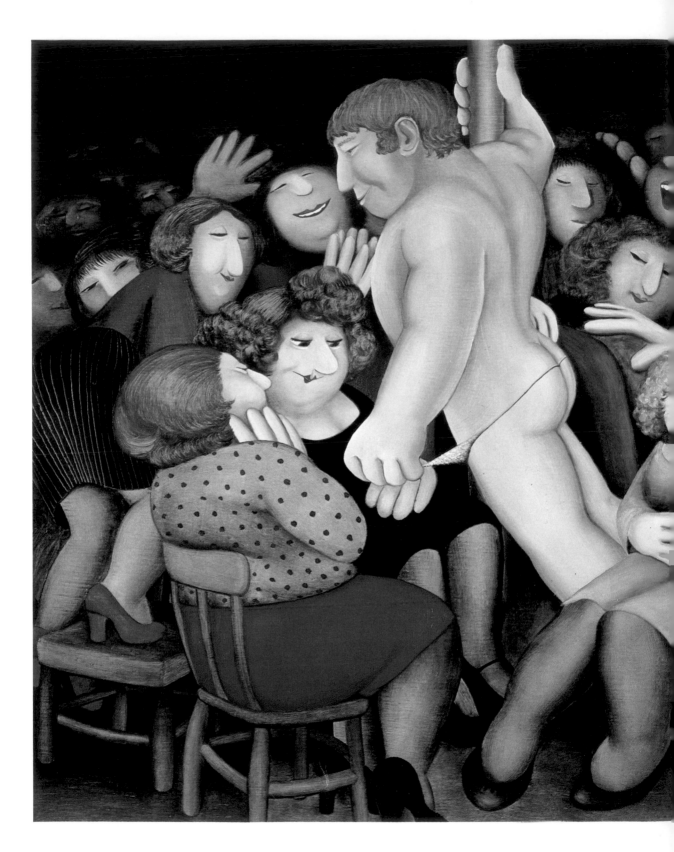

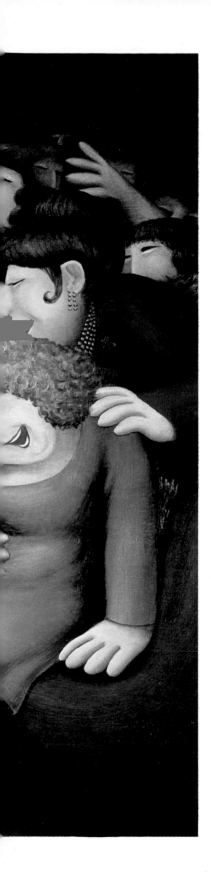

Ivor Dickie

I doubted whether I would be able to get a painting from this, much as I wanted to. After some time thinking about it I decided to try and draw the audience, handsome women dressed in their finery and out to enjoy themselves, and gradually the picture formed. He had a very fine figure and liked lots of clapping and loud cries of 'get 'em off' to get him going, which I supplied. I'm rather pleased with the expression on the face of the lady in black—*exactly* right I feel—and I tried to get in all the hands extended towards him, which to me was very noticeable.

Jackson Square

This is one of the results of a much looked forward to visit to New Orleans, when I very bravely flew all the way to America. Fortunately I managed to persuade myself to sit quietly in my seat, drinking, and not run amok in the gangway, or I would never have had the chance of seeing this lovely place. Jazz bands play in the public gardens as well as in most of the bars, and this is what we saw on our way through Jackson Square to sit by the Mississippi and watch the riverboats go by.
What I haven't yet painted are the little boys tap-dancing in extremely large shoes outside the bars— until a policeman comes along, when they race off at top speed with whatever money they have collected.

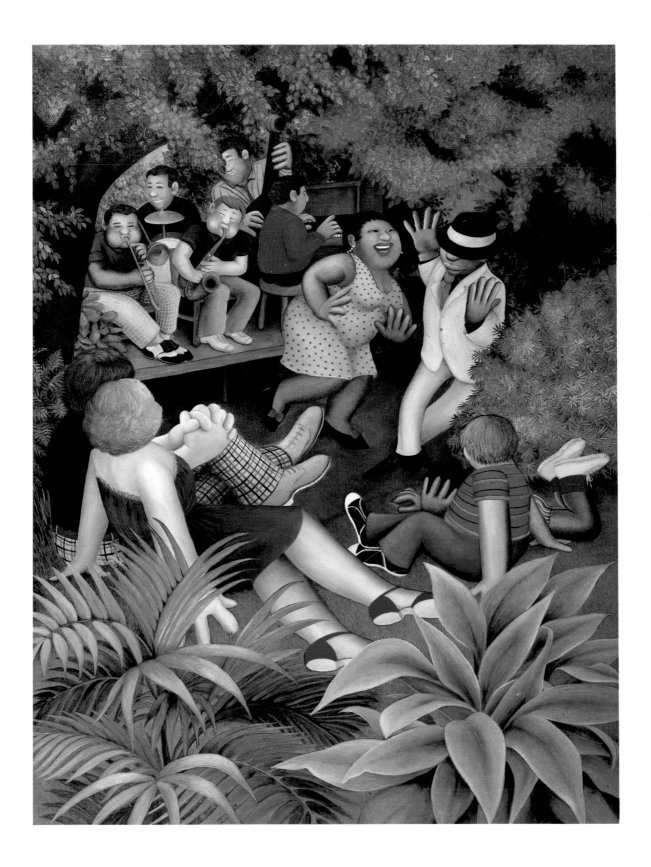

Conversation Piece

I saw these two in a bar and I took such a fancy to his hair and the way he was leaning on the table that I made a small sketch on the spot. But the difficulties arose when I tried to paint him, and I grew so tired of the whole thing I hastily finished her off in black so that I could go on to something else. Now I have grown fond of the painting and placed it just beyond my easel; so he stares at her and I stare at him, mesmerised, whilst quietly composing yet another masterpiece.

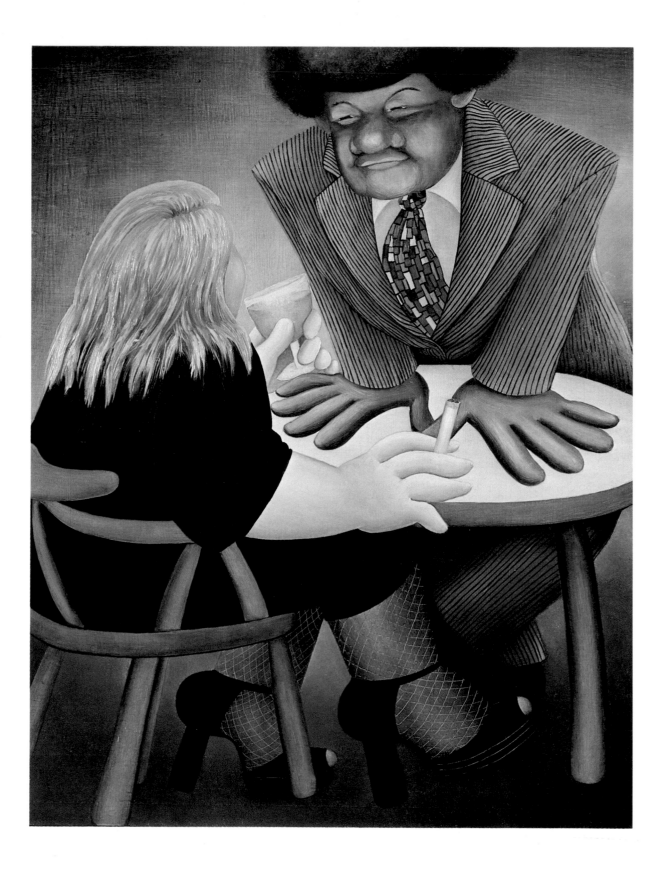

Audubon Park

We saw this man nattily attired in white from head to toe swinging down Bourbon Street. After some unsuccessful attempts to paint him as he was, I decided to move him onto a park bench in the zoo at Audubon Park, where we had had lunch with the squirrels and watched the toucans. It was so hot I could easily have slept the afternoon away (and several did) but the squirrels diligently collected, stored and ate scraps of food without pausing. I treated myself to a Snoball but rather wish I hadn't.

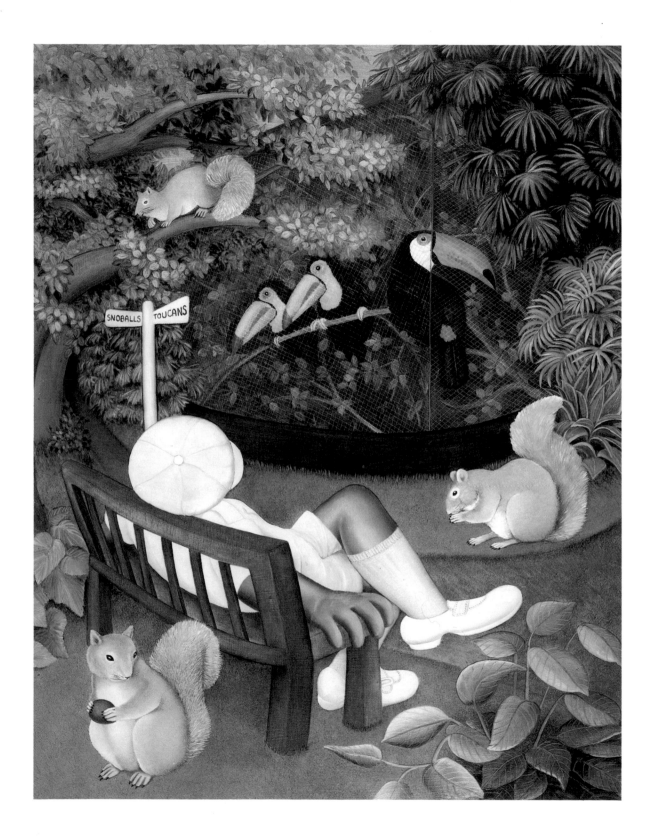

Jackpot

This, alas, records the end of our journey to
America. We travelled back in great excitement
on the Q.E.2 and in the casino this lady told me
that if I wanted to win the jackpot I must take
my shoes off. She had removed hers and was
having great good fortune. The food on the
ship was most delicious but so abundant that,
despite strenuous efforts, I had to refuse rather
a lot: I knew I'd regret it, and so I have.
Of all the American paintings, this is the one I
decided to keep for myself as a memento of all
the exciting things we saw, so John made a
special frame to match the dress and shoes.

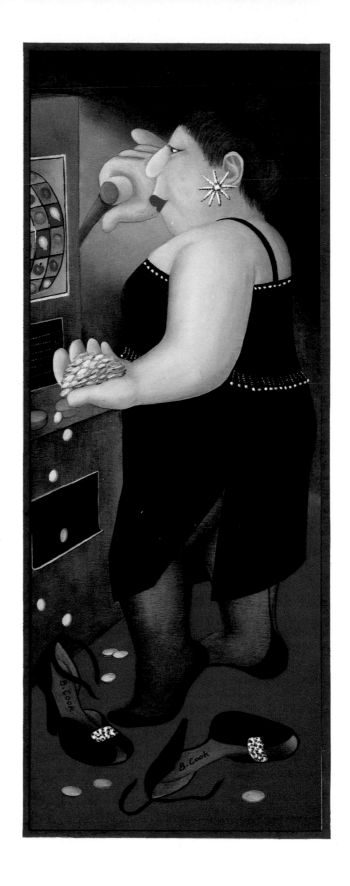

Union Street

A walk along Union Street on a warm summer's
evening, with the boys and girls dressed up, and
out to enjoy themselves, gives me great pleasure.
One night we visited several pubs and Diamond
Lil's club and afterwards I painted this picture,
putting together all the things I had seen and liked.
It was then fashionable for some girls to wear no
skirts, just a long sweater tied on the thigh, and we
had seen one girl wearing a particularly nice one,
her outfit completed by black spotted stockings.

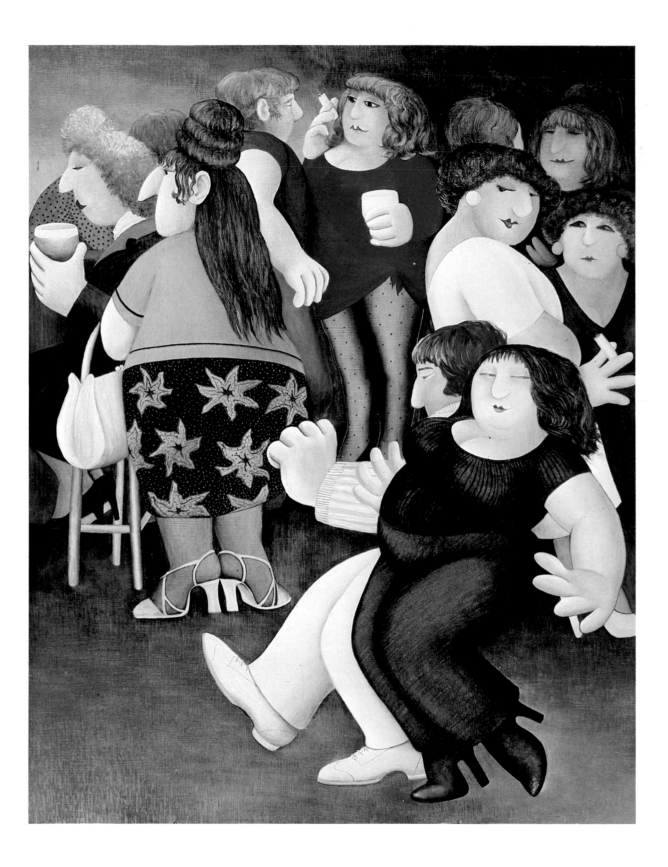

Window Dressers

This sight was revealed when the lift doors in a
large store opened wide for a few seconds and
closed again after leaving the scene imprinted.
on my mind for ever more. Even now I can see
clearly these two men struggling to arrange the
mannequin on a large, luxurious, four-poster
bed. As her wig dropped off onto the pillow I
knew instantly that this would be my
opportunity to paint a bald lady.

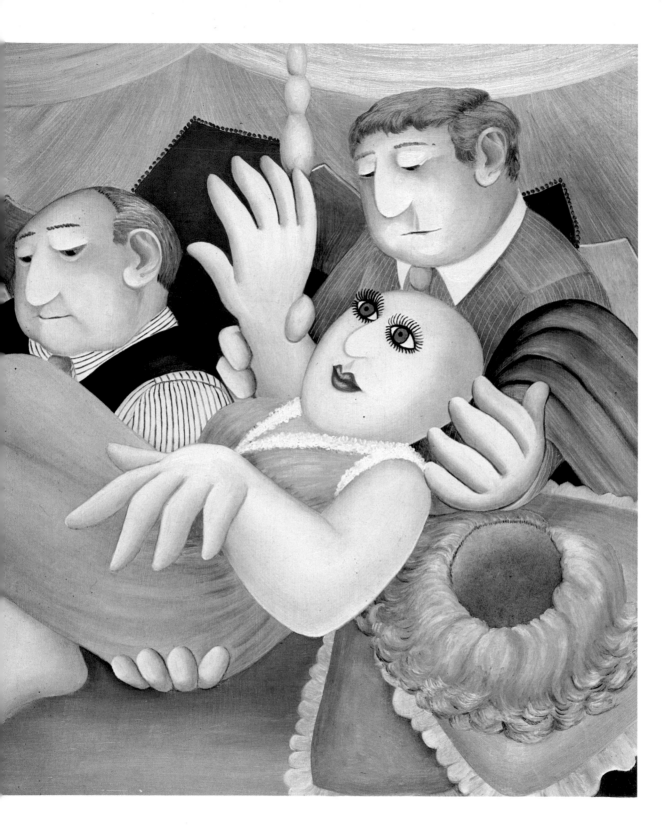

Man with Blue Eyes

I found these little doll's eyes in the flea-market in Amsterdam, and knew at once that they were just what I needed for a painting. This was a grave mistake, for three weeks later they were still staring at me reproachfully. I felt I must use them at all costs or give up painting, so I stuck them on here, where luckily they fit quite well.

I like adding oddments to the paintings sometimes and have handy pieces of hair, old spectacles, teeth, dolls' hands and all sorts of things stored away. In my view most things will come in useful one day, but this habit does tend to restrict movement through the house.

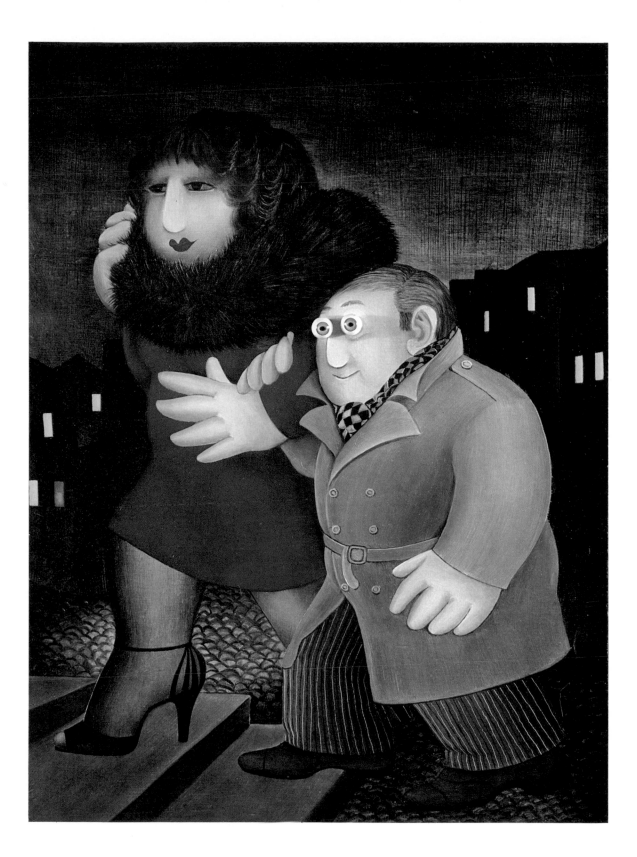

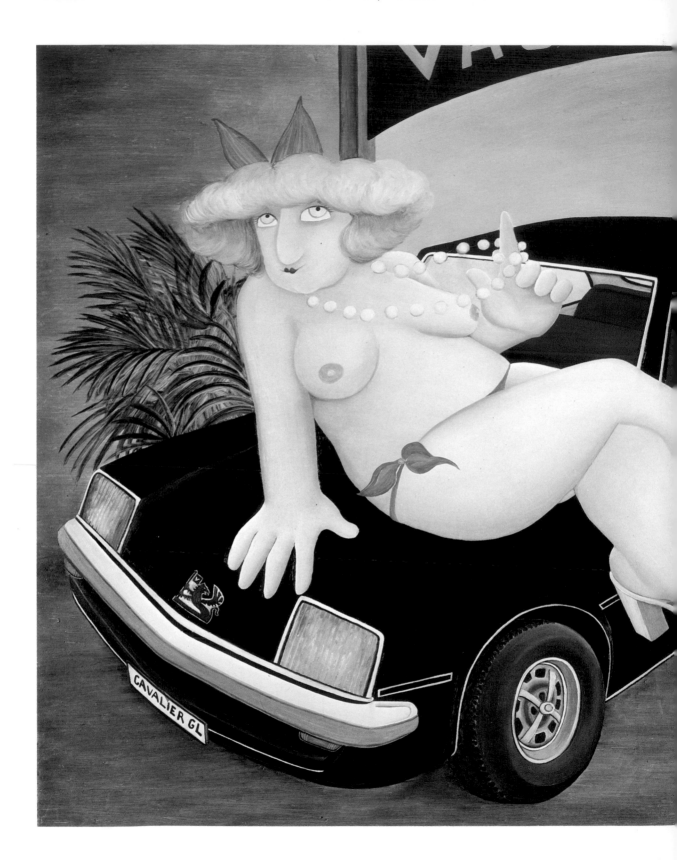

B. Cook

Motor Show

Although John has taken me to
motor shows on two or three
occasions, I have never been lucky
enough to go when the topless girls
are there. I like painting both flesh
and motor cars, and so decided to
do my own version. I never learned
to drive but would really love to
have a customised car, a Rolls
Royce for preference.

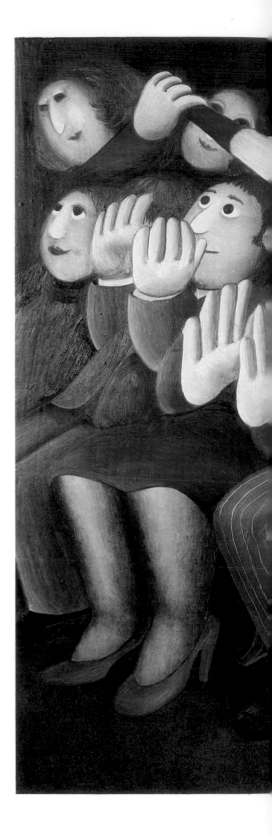

Balletomanes

I am very fond of ballet dancers, the men in particular as they sail through the air in the tightest of tights, and this is what I intended to paint here; but as you can see it turned out to be the audience. As I was trying to diet at the time each of the chocolates is lovingly depicted, copied from one of the charts inserted in every box and saved by me for future reference. I am quite sure that this is not my last attempt at the ballet: when I do get a picture of the dancers *I* shall be the one dancing with Rudolf Nureyev.

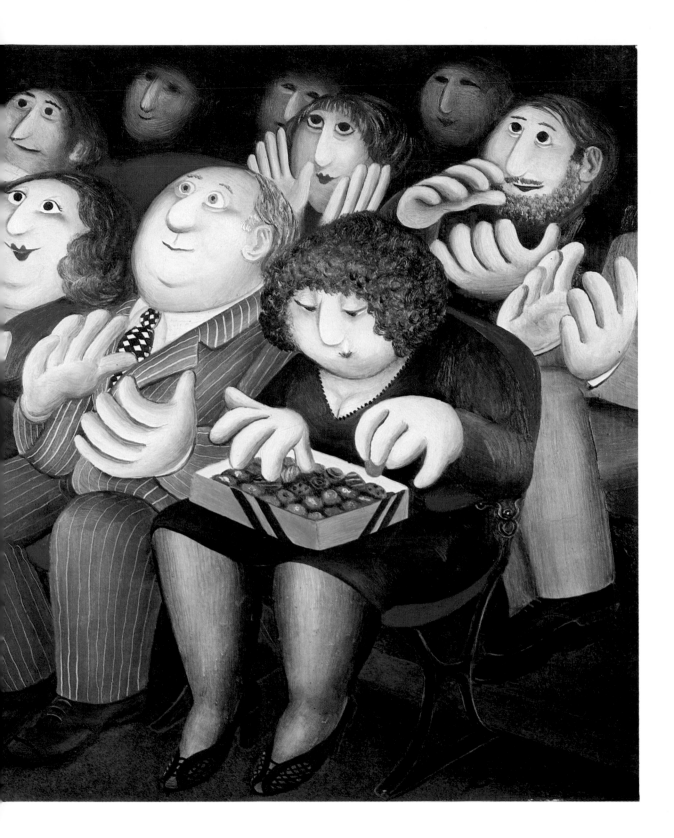

Ted and Heinrich

These are friends arriving on a cold winter's night
at Plymouth Station, where we had gone to meet
them. I loved the effect of the fur coat, the cloak,
and Bertie straining at the leash, and I decided to
celebrate it all with a picture. My problem here was
painting a train, and to disguise the fact that mine
didn't seem to look like the one I was copying from
a book, I made the figures as large as possible.

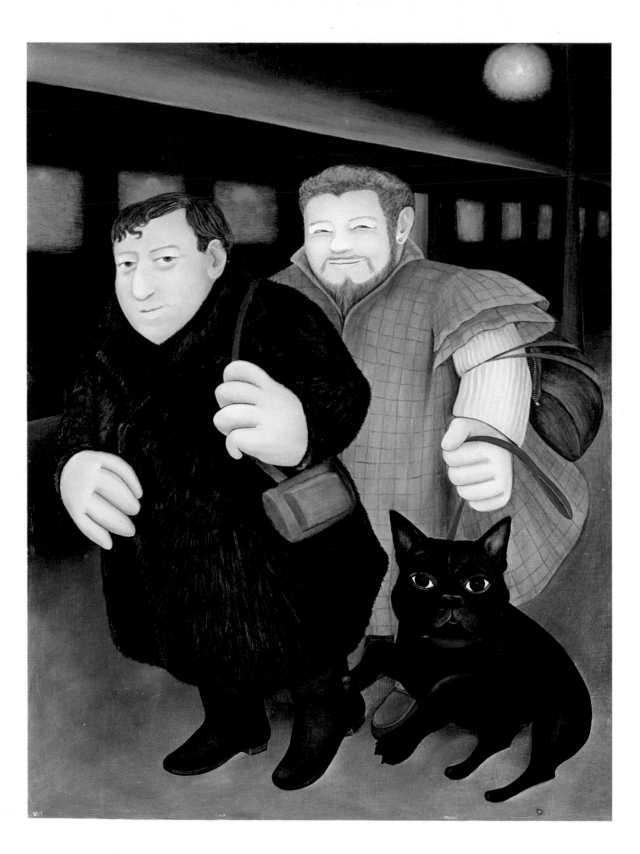

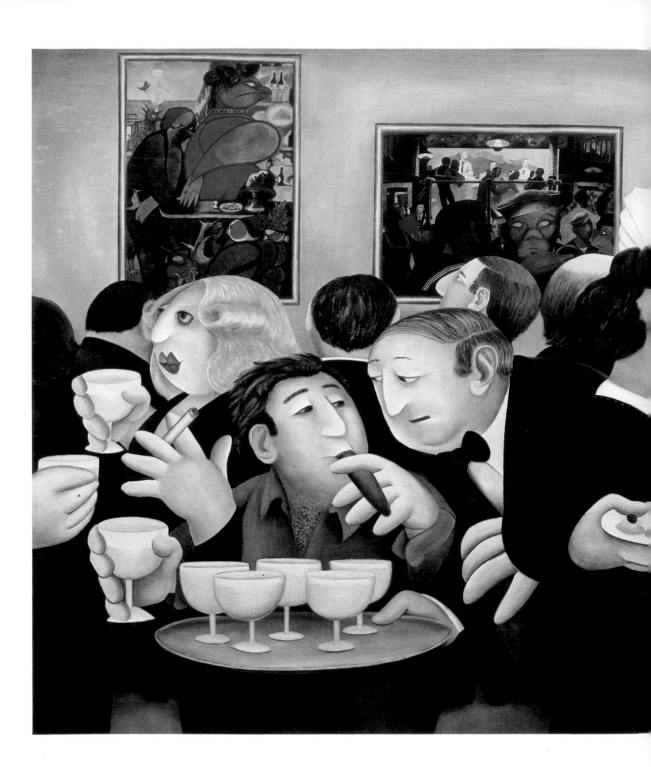

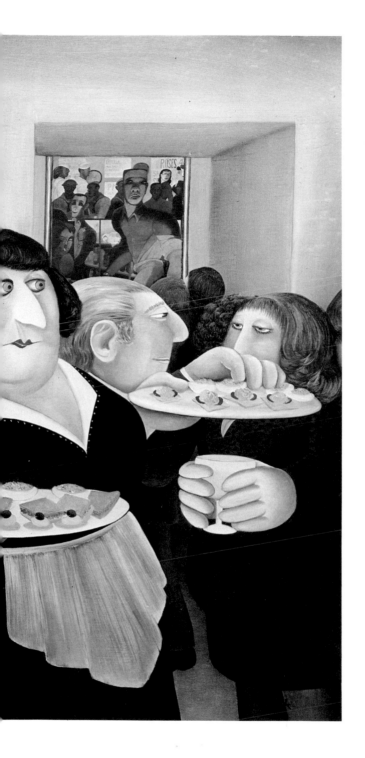

Private View

Edward Burra's paintings give me intense pleasure and we were very glad to be invited to this private view at the Lefevre Gallery. When I tried to record the occasion in a painting I found, as usual, that it was much more difficult than I had thought. Just as I was about to abandon it, inspiration arrived in the form of a letter from the friend who had invited us to the exhibition: her description of some of the people who arrived after we had left gave me just the incentive I needed to finish it. I cut some pictures from the catalogue to use as his paintings on the walls and hope that some of their lustre will rub off on mine.

Tattoo Artists

This is a favourite subject for me, and luckily I am able to see quite a lot of tattoos on the sailors around here. When I pass Doc. Price's tattoo shop I am often tempted to have one myself: something rather genteel I think—like my paintings.
Once I saw some sailors peering through the window to see what was going on and another time I was able to watch a young man having his arm tattooed with a flower. To my surprise I found that blood appears as the needles trace out the pattern; it had not dawned on me before that the procedure might be painful. I put both incidents together in the painting and gave him a mermaid and a fish as well, being rather suitable for a seaman.

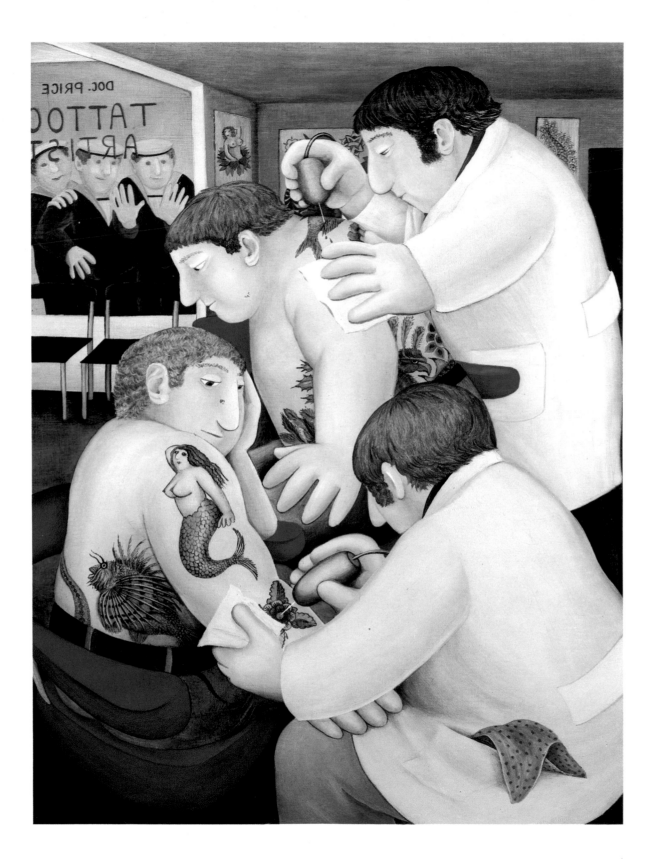

Punks on The Hoe

After Bonzo and I saw these punks roller-skating
on the Hoe I hurried home to record as many
details of their clothes and hairstyles as possible, a
never-ending source of pleasure to me. My own
choice would be leopard-skin hair. I am told that
the way to get the hair standing in peaks is by using
soap. I feel that I haven't got time for this in the
mornings, but my hair often looks like that anyway.

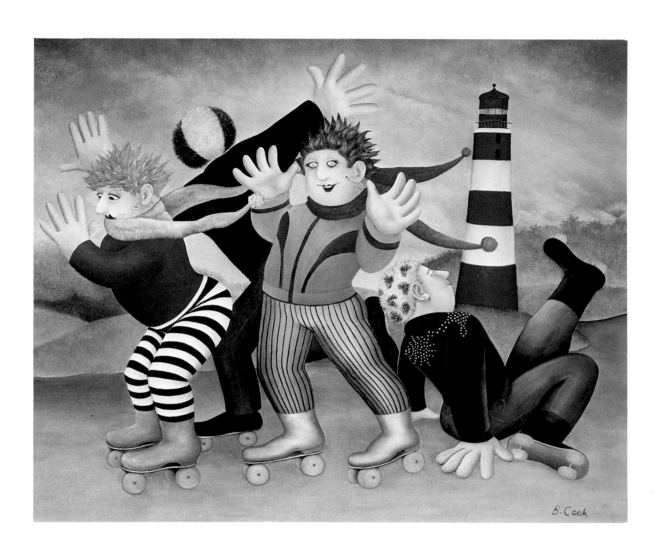

Divine Visitation

We were just removing an enormous roast dinner
from the oven one Sunday evening when the
doorbell rang, and during the few seconds it took
me to open the door, cry 'no thanks' and close it
again this scene registered itself, indelibly. I
guessed that they had had some practise in
arranging their faces in just the right expression of
friendliness and reassurance and took great care in
trying to capture this.

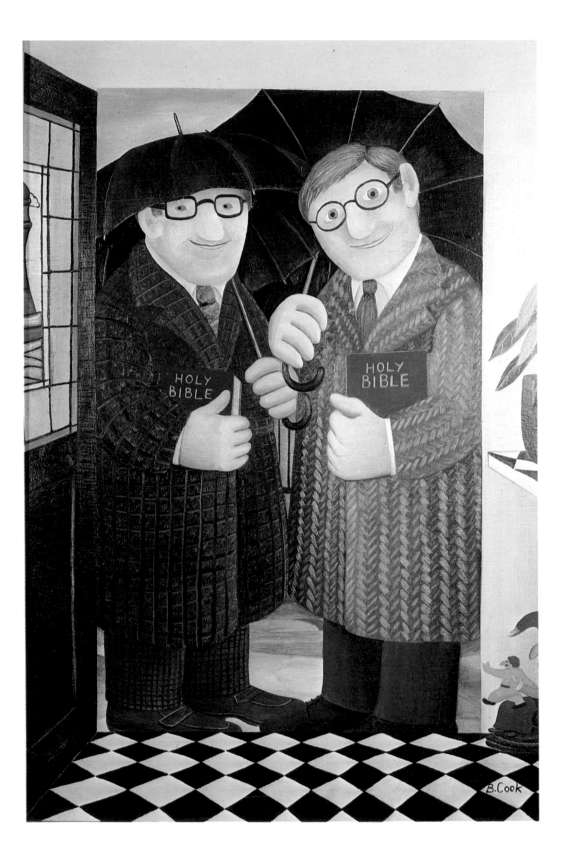

Salvation Army

The first Sunday in July every year the Salvation Army holds a convention in the city centre. This I find very exciting for I love the bands and think the girls particularly attractive in their uniforms. I was greatly taken with these two, watching the marching and the banners flying, and after a lot of groaning and shuffling around copies of the *War Cry* (which we get in the pubs) I finally managed to draw and paint it. I copied the musical instruments from the magazines, but had to leave out quite a few pieces of them, they were so complicated.

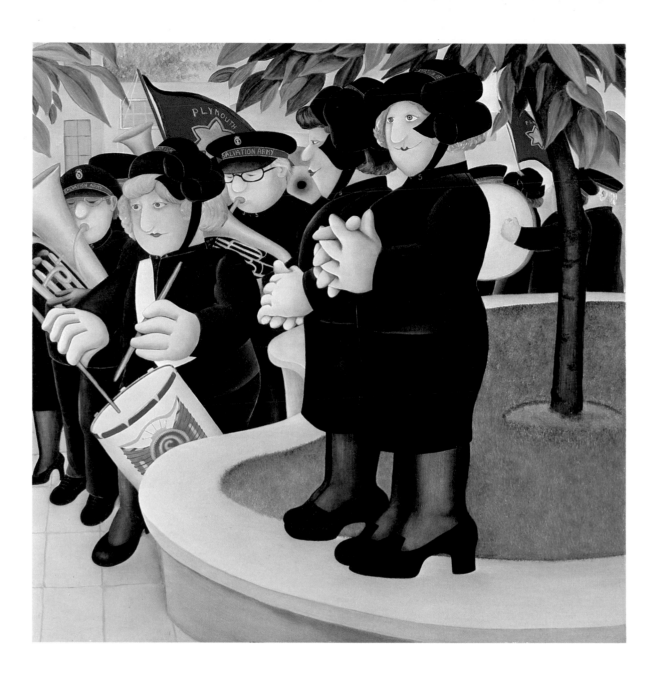

The War Cry

This was painted because I liked the back view of the white dress so much. I also like to see the Salvation Army officers with their magazines threading their way through all the people. I hope it won't become too noticeable that the people are getting larger and the backgrounds smaller (or non-existent) in the public house pictures. It is to save me the trouble of painting all those bottles on the bars, for I am not only lazy but very impatient to get on with painting the people.

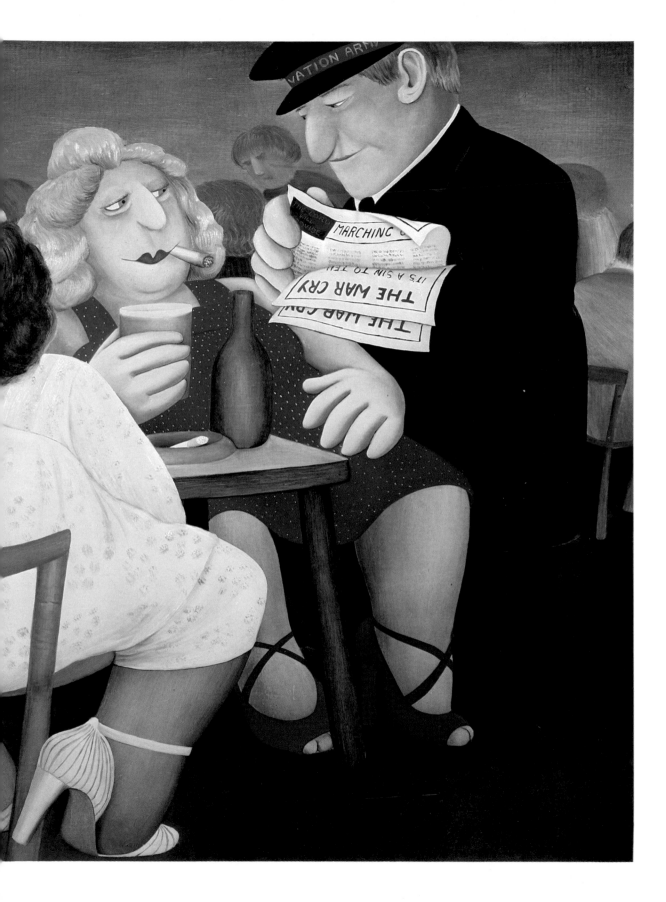

Beer Garden

This is painted on canvas, a rather second-hand one as I'd had to remove several unsuccessful attempts at another subject before deciding she might fit. We had been sitting in a beer garden one Sunday morning when she hove into view, surrounded by children, and then sat gazing into space—possibly recovering from a rough Saturday night. I drew her when we got home, but then forgot her until the bare canvas could be ignored no longer.

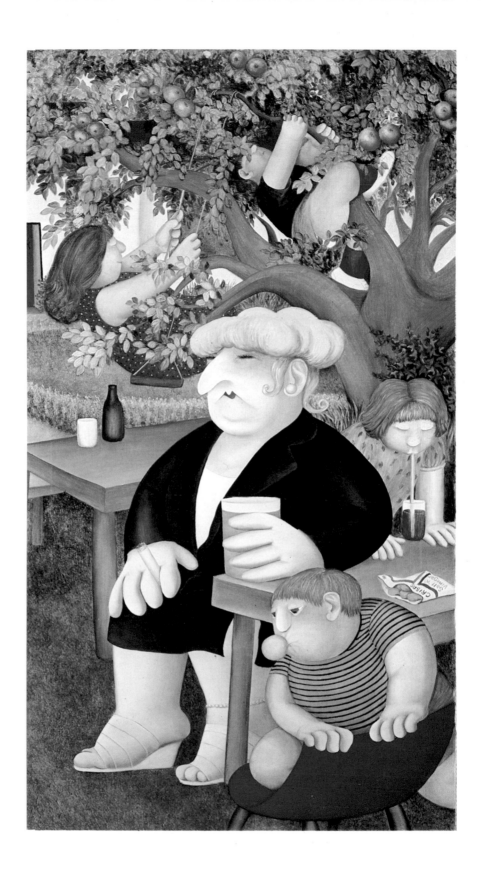

Jubilee Day

Action-packed for us and even more so for Harry, Tommy and Brian in this painting. Tommy sang and danced the whole way home in and out of the gutter, emphasising the high points of his song with the umbrella. Harry danced half way but gave up after a couple of falls and allowed us to support him whilst harmonising with Tommy. Afterwards I felt an urgent need to lie on the sofa but was startled to see Brian at the window dressed like this, a couple of hours later. In that time he had been home and made himself a complete Jubilee outfit and was setting off for the evening. We hope Her Majesty has another Jubilee Day soon.

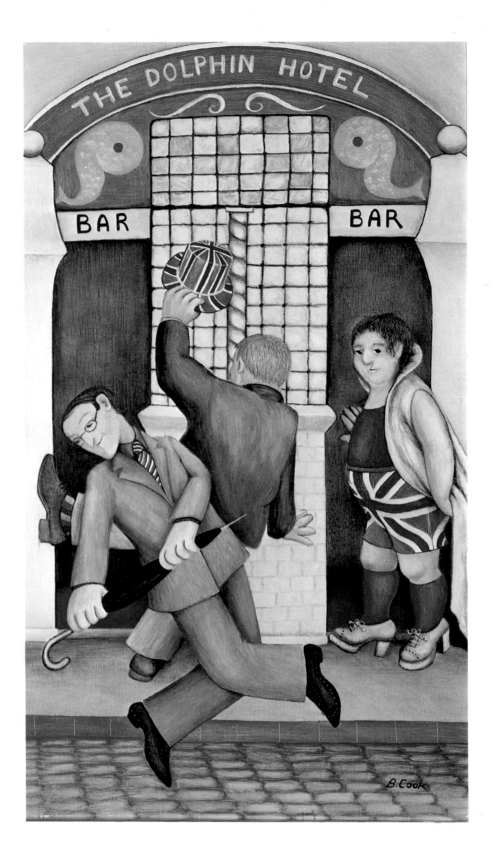

Musical Evening

This is a very old painting, dating from when hippies gave up wearing shoes. Opposite us sat two men who were suddenly joined by a friend with very crossed eyes. Comfortably seated on a lap, she pulled out a mouth-organ and played while they sang for the next half-hour or so. This was thoroughly enjoyed by both them and us, but I've never had the pleasure of seeing it again.

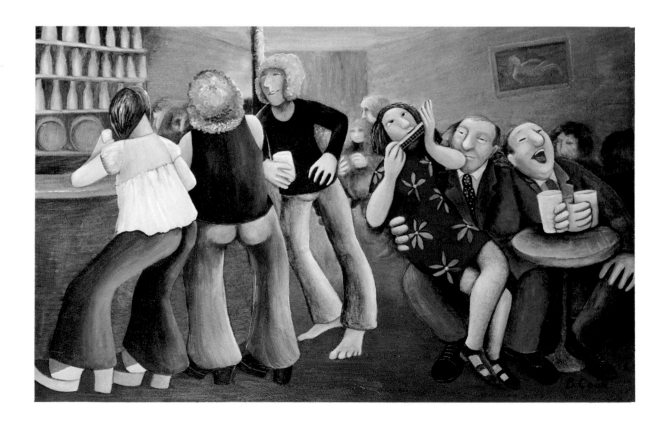

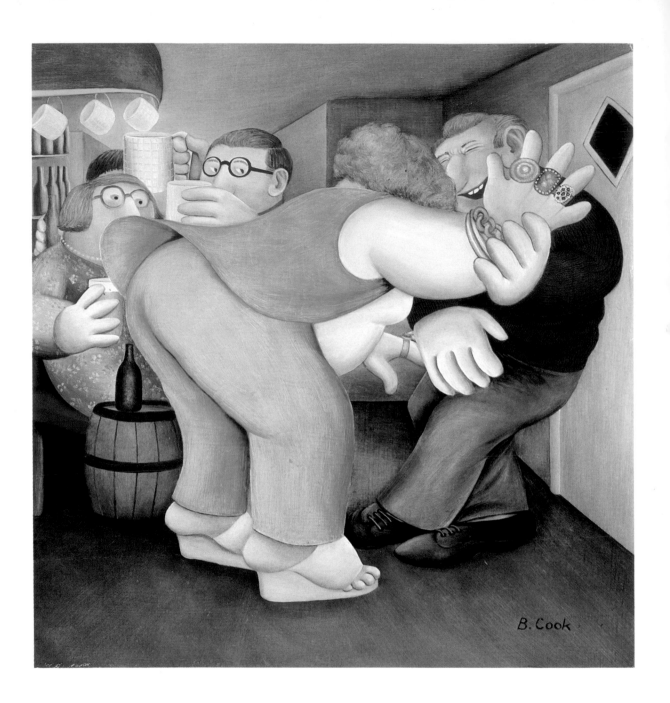

Ticklish

I would like to say now that I do not spend all my
time in public houses. Most of it is spent painting—
or thinking about it. But we did just happen to be in
a pub when these two were messing about. He had
been teasing her for some time when she suddenly
turned on him and he, helpless with laughter, tried
to stave her off. There is a roundness about this
painting that I like very much, but when it was
finished I was surprised to find there were so few
people in it, for I remembered the room being quite
full. That must be me in glasses, watching.

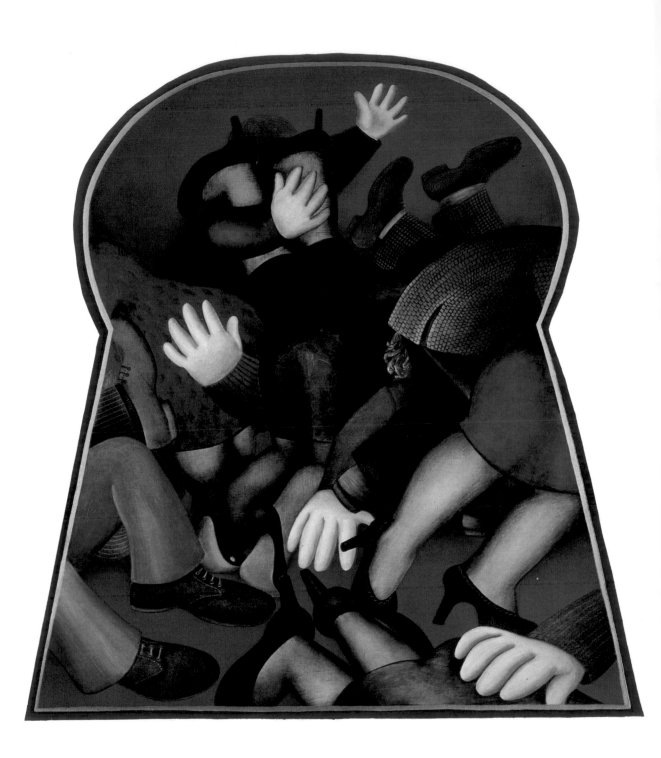

Through the Keyhole

I don't know what is going on here, though someone suggested that it might be a glimpse of a department store during Sales time. It is the result of a suggestion that I should paint a keyhole picture, and a very large keyhole it turned out to be. When I had finished the painting, and puzzled for some time over what all these people might be doing, a further suggestion was made—that I might like to paint the butler watching them from the other side of the door.

And this is the butler.

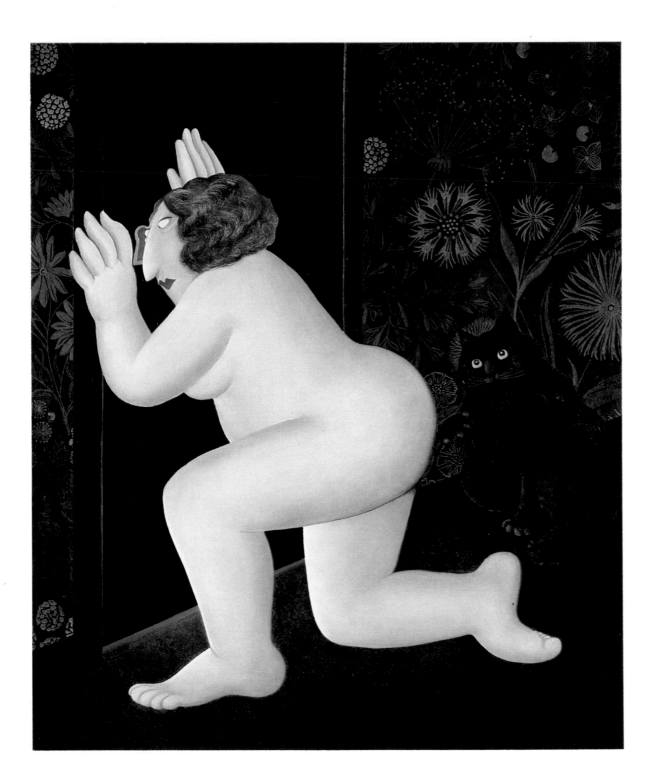

Next!

I hardly know what to say about this painting, except I hope you notice the bead curtain. I like these very much indeed—we have three—and it took me a long time to paint.

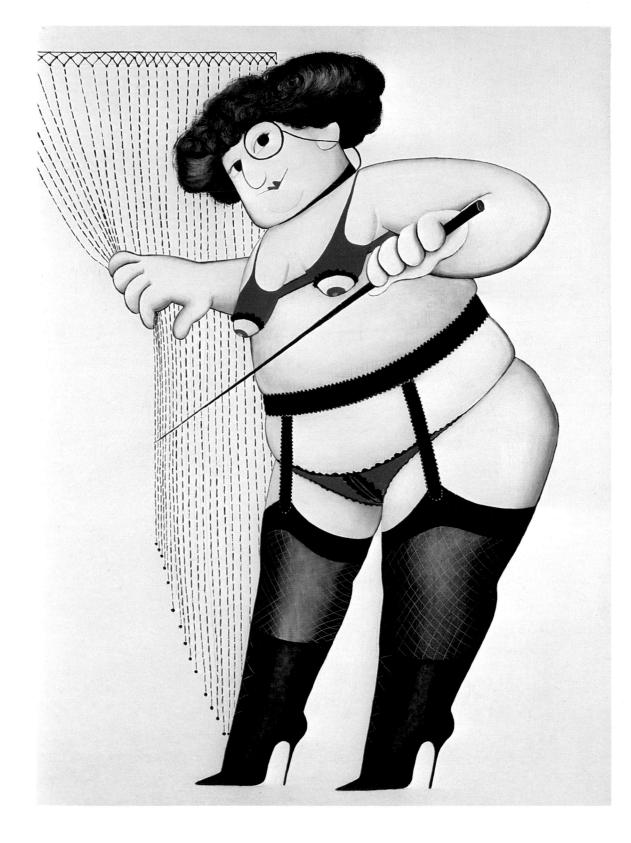

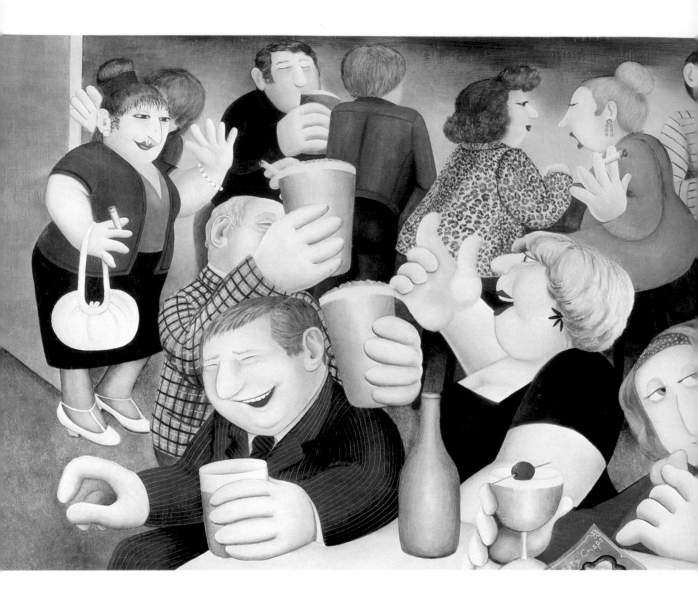

Saturday Evening

I don't often see people dancing in the pubs now and think there must be some new regulation forbidding this; I wish it were not so for I used to thoroughly enjoy it. I would rather like to get up and play the spoons at a certain stage in the evening and sometimes think I will practise, in case I'm ever invited (or allowed) to.

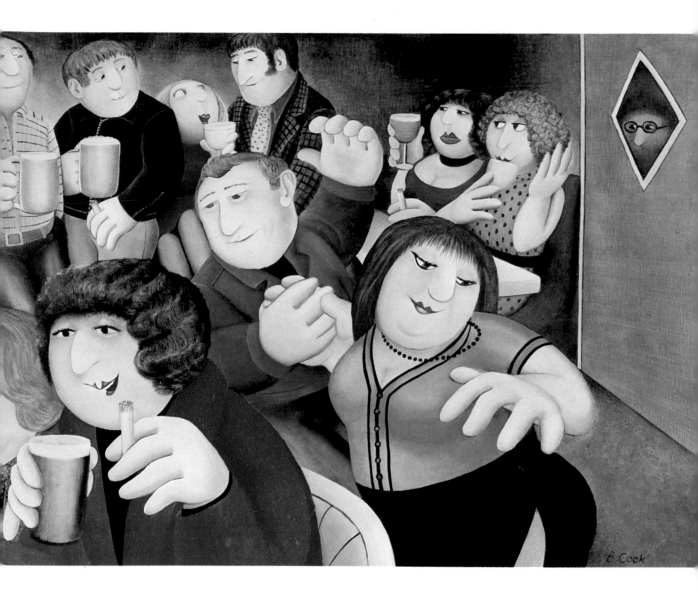

This painting and the next were originally designed to be
printed round large beer cans, and with a little imagination
you will see just what the man on the far left of the picture
is intending to do.

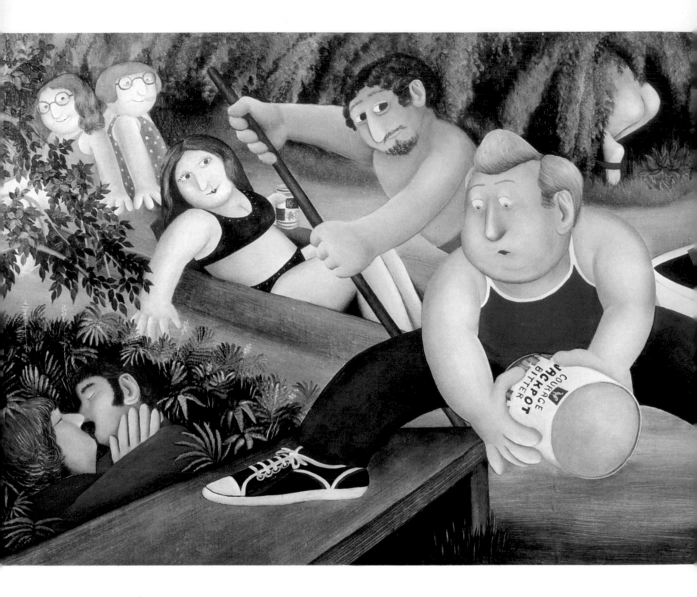

Sunday Afternoon

Another brewery picture. John suggested this subject, for
we lived near the Thames in our youth, and great pleasure
it gave me to try and bring it back again. On looking at it
now I realise that everything going on here is based on our
various activities during that time, including falling into the
river, a misfortune which befell us on our wedding day.

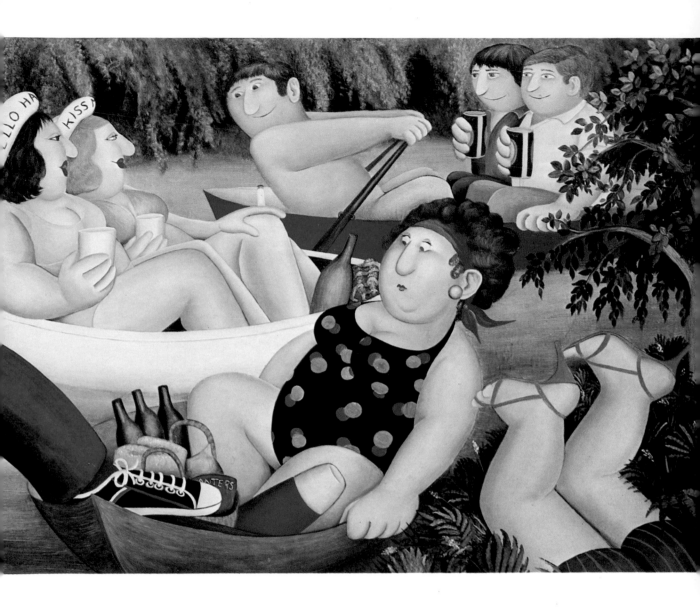

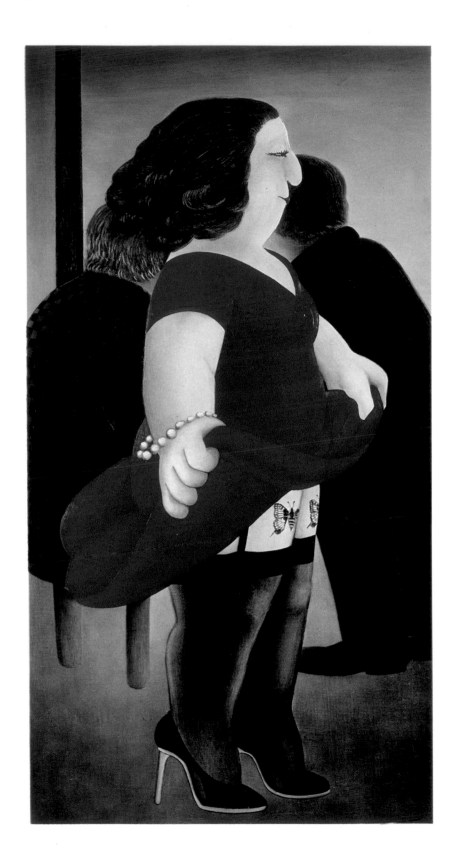

Girl with Tattoos

I did not really get a glimpse of the tattoos, in fact she assured us that she hadn't any as she lifted her skirt high to demonstrate. For me though she became tattooed the minute I was told that they were on her thighs, and this is how I painted her. I liked her so much I painted her twice, the second time with even bigger tattoos.

Hair

My intention was to tease out both Daniel's and the lions' hair so it would fill the top half of the painting completely, and I nearly succeeded, but I find that things rarely turn out as intended. Usually the final appearance of the paintings comes as a grave disappointment, but I know that if I keep them for a while I will come to accept them for what they are, and feel glad I was able to paint them at all.

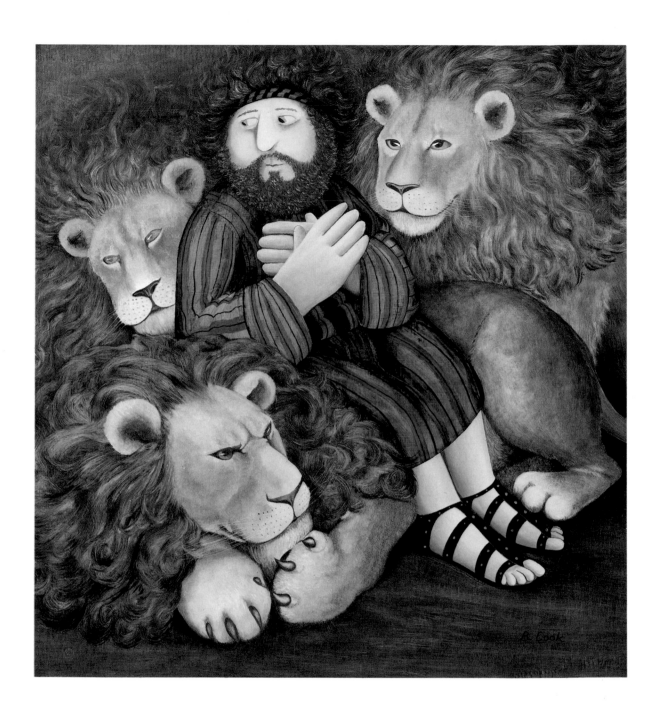

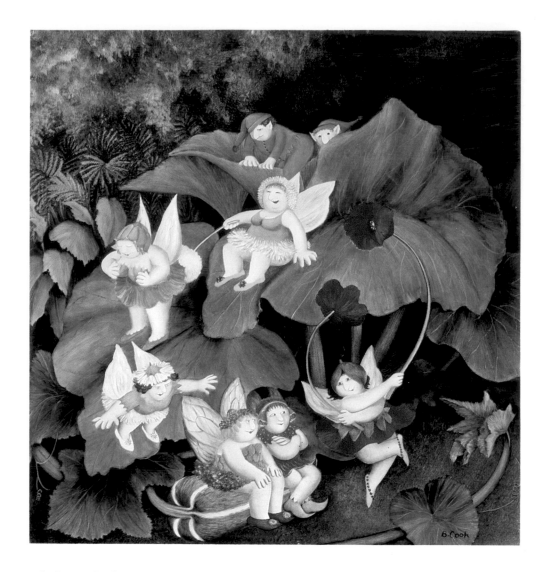

Acknowledgements

The following have kindly given permission for their paintings to be reproduced:

Divine Visitation, Mr & Mrs J. W. Allen; *Audubon Park*, G. Saunders Esq; *Private View*, Barbara Ker-Seymer; *Ladies Night*, Gay Search; *Hair*, David Walser; *Musical Evening*, Tony Martin; *Jubilee Day*, Alan Gatward; *Bertie in Bonzo's Basket*, Edward Lucie-Smith. The following paintings are in Private Collections: *Saturday Evening, Sunday Afternoon, Jackson Square, Tattoo Artists, Motor Show, Union Street, The War Cry, Ticklish, Punks on the Hoe* and *Balletomanes*.

A limited edition print of *Fairy Dell* is available from The Alexander Gallery, Bristol

Beryl Cook's paintings are sold in London through Portal Gallery Ltd

Greetings cards and prints of a number of Beryl Cook's paintings are available from Gallery Five Ltd, London